Бор

THE LIFE & TIMES OF CLAUDE MONET

THE LIFE & TIMES OF

Claude Monet

BY
Edmund Swinglehurst

SHOOTING STAR PRESS

This edition printed for, Shooting Star Press Inc, 230
Fifth Avenue, Suite 1212, New York, NY 10001

Shooting Star Press books are available at special discount
for bulk purchases for sales promotions, premiums, fund-
raising or educational use. Special editions or book
excerpts can also be created to specification. For details
contact – Special Sales Director, Shooting Star Press Inc.,
230 Fifth Avenue, Suite 1212, New York, NY 10001

This edition first published by Parragon Books
Produced by Magpie Books Ltd, 7 Kensington Church
Court, London W8 4SP
Copyright © Parragon Book Service Ltd 1994
Illustrations courtesy of: Christies Images; Mary Evans
Picture Library.

ISBN 1 57335 044 3
A copy of the British Library Cataloguing in Publication
Data is available from the British Library.

Typeset by Hewer Text Composition Services, Edinburgh
Printed in Singapore by Printlink International Co.

CLAUDE MONET

The artist Paul Cézanne is said to have remarked about Claude Monet that he 'was only an eye – but what an eye'. Like many *bons mots*, this conceals as much as it reveals about its subject. Some take Cézanne's remark to mean that he considered Monet to be limited in his approach to painting, merely recording what he saw like a camera; others think that Cézanne was hinting that Monet lacked the intellectual creativity which produces great works of art. More perceptive art-lovers may remem-

ber that Cézanne climaxed his assessment of Monet with the words 'He is the greatest of us all'.

Cézanne's own art had a great deal of thought behind it. He was concerned, as were the atomic scientists of his time, with defining the structure of matter. Could it be, perhaps, that Cézanne perceived in Monet another approach to the definition of the material world, an approach which instinctively leads to a scientific view of a world of particles and wavelengths?

If one thinks of Monet's later work, such a possibility is not unlikely. In Monet's work after about 1890, outlines begin to disappear and horizons to vanish; the picture is no longer constrained by its physical limits. Monet plunges into a world of pure colour without making any attempt to define form by a precise outline, unlike most of the artists

following the Cubist route indicated by Cézanne.

The last twenty-seven years of Monet's life, dedicated almost entirely to the creation of his spacious and colourful paintings of his lily-pond at Giverny, were his final attempt to interpret the world in his terms. He thought he had failed. But to those of us who see his work, Monet opens a window into another kind of vision, just as Cézanne's 'failed' efforts did.

Claude Oscar Monet was born in Paris on 14 November 1840, where his father kept a grocery store. Before the boy's fifth birthday, however, the Monet family moved to Le Havre, where the River Seine meets the sea on France's northern coast. Thus the young Monet grew up with the fresh atmosphere of the sea all about him. The love of the sea and

of the River Seine remained with him all his life.

At school in Le Havre he was not particularly studious and spent much of his time drawing cartoons of his teachers and colleagues in his school exercise-books. This talent for cartoon and caricature soon began to earn him some money, both from local citizens willing to pay him ten francs a time for an amusing cartoon, and from local newspapers, journals and shops.

Monet might have made his career as a cartoonist had he not met the painter Eugène Boudin. Boudin, who was born in Honfleur but lived in Le Havre, was sixteen years older than Monet and was making a modest living painting scenes of the seashore. The older painter took the younger one under his wing, inviting him to come on painting-excursions along the coast and to

take up painting in the open air. Both these ideas were new to Monet, but Boudin's enthusiasm persuaded him to give them a try. This was the time when Monet, still in his teens, began, as he said later, 'to understand nature'. In later years, Monet paid tribute to Boudin's influence on him: 'It was as if a veil was torn from my eyes, I understood what painting was about.'

At this time, Monet knew very little about painting and had seen few paintings in museums or art galleries. He decided that he should therefore return to Paris. Selling cartoons and accepting a small allowance from his father, Claude Monet was able to scrape together enough money to pay for a visit to the capital in 1859. There he met Boudin's former teacher, Constant Troyon, well known as a landscape artist and painter of animals. Troyon may have been a conventional artist, but he was able to introduce

Monet to various artists and writers, including Gustave Courbet, whose Realist ideas were creating a break with the conservative, academic art of the period.

Monet quickly made friends in Paris. He soon joined the Académie Suisse where he met Camille Pissarro, the originator of the style of painting that would become known as Impressionism. Pissarro was already an established painter, having had his work exhibited at the Paris Salon.

The only dark cloud on Monet's horizon at this time was his family's disapproval of the life he was leading, which caused his father to cut off his allowance. Then, in 1861, came another blow to his artistic career, when he was called up for military service for a period of seven years, and sent to Algeria. While there, he fell ill and was repatriated. During his convalescence in France, someone was

found who was willing to act as a substitute for the rest of Monet's military service, enabling him to take up his life among the artists in Paris once again.

Although his guiding star was still Boudin, he now met another painter with whom he felt a special affinity. This was the Dutch artist Johann Jongkind, whose paintings, with their spacious and luminous skies, gave Monet a new interest in the effect of light in the atmosphere. Jongkind joined Boudin and Monet in a painting-expedition to Honfleur, where they painted the coast and the harbour. In the evenings, they joined other artists at the cafés. Monet wrote enthusiastically to his friend Frédéric Bazille in Paris, regretting that Bazille was not with them in what was becoming an artistic milieu on the north coast of France. 'Some of the painters,' wrote Monet, 'are very bad ones at that.'

THE IMPRESSIONISTS

Back in Paris, in the autumn of 1862 Monet began to go regularly to the studio/school run by Charles Gleyre, a former instructor at the Ecole des Beaux-Arts and an open-minded man who allowed his students much freedom of activity. Among the students at Gleyre's studio at this time were Bazille, Alfred Sisley and Auguste Renoir, who became Monet's life-long friends. He also met Degas and Toulouse-Lautrec.

Although the atmosphere at Gleyre's was stimulating enough to keep Monet attending classes at the studio for over a year, he was soon restless, feeling that, already, he was beyond reach of Gleyre's criticism. Monet wanted to strike out on his own and develop his own ideas about painting. By mid-1863, he was spending long periods, sometimes alone, sometimes with his friend Bazille, in the forest of Fontainebleau, where he had based himself at a small village called Chailly. Both artists found the atmosphere of the forest stimulating, although Bazille soon recognized that, at least in the painting of landscapes, Monet was very much his superior.

By the early summer of 1864, Monet was back on the north coast, where he set up house at Honfleur with his friend Bazille. Bazille, who was Monet's closest friend and a very fine and original artist, came from a

wealthy family in Montpellier, in the south of France. For Monet, this was both an advantage and an inconvenience. Bazille was a source of money when Monet needed a loan – which was often – but he was also, to a young man brought up in far from affluent circumstances, the cause of slight feelings of irritation. This factor was to colour their relationship until Bazille's untimely death in the Franco-Prussian war in 1870.

Although he was happy in Honfleur, Monet still hankered after the artistic life of Paris, though he could not afford to live in the capital. Fortunately, at this point in his life, his father changed his mind about his son's ambition to be an artist and reinstated his allowance. By 1865, Monet was back in Paris, living in a studio in the rue Furstenberg, which he shared with Bazille – who paid most of the rent and other expenses.

Within a year, Monet was beginning to know real artistic success. He had two paintings accepted for exhibition in the Salon of 1865, *The Seine Estuary at Honfleur* and *The Pointe de la Hève at Low Tide*, both of them large canvases. Although they were studio paintings, they were both based on smaller studies he had painted in the open air during the summer.

The following year, two more paintings with Monet's name on them were hung in the Salon. *The Forest at Fontainebleau* was another landscape, favourably received by the critics. But it was *Camille, or Woman in a Green Dress*, the model for which was Camille Doncieux (later to become Monet's wife), which really caused a stir. This life-size painting was rumoured to have been painted by the artist in just four days, when he had realised that he would not finish the picture he hoped to have ready for the Salon, a vast *Déjeuner sur*

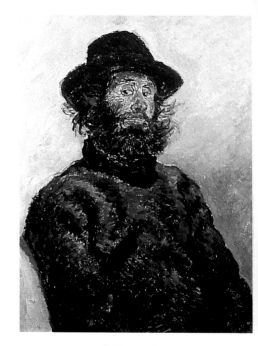

Self-portrait

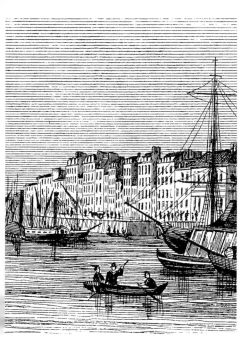

Le Havre in Monet's time

l'Herbe. Woman in a Green Dress was not a portrait; it was a wonderfully successful attempt to capture in paint a fleeting gesture, a movement in the dress. Monet was awarded a prize for it, and received much critical acclaim. He also won the friendship of Edouard Manet, who had been somewhat irritated when his name had been confused with that of Monet at the time of the 1865 Salon: some people had assumed that Monet's two landscapes had been painted by the better-known Manet.

Success in the Salon fired Monet with fresh ambition. Back in the garden of the house he was now renting in Ville-d'Avray, he set out to paint a large canvas, completely out of doors. It was to be a scene of women in a garden, with his mistress Camille modelling all four of the women he planned to include in it. The canvas was so large that he had to dig a hole in the garden to lower the canvas

into so that he could reach its upper area. The painting, the wonderful *Women in the Garden*, now in the Musée d'Orsay in Paris, was intended for the Salon of 1867. But when Monet presented it, the judges refused it.

This was the beginning of a bad time for Monet, who was seriously short of money during most of the 1860s and 1870s, even though his early successes at the Salon brought him both commissions and sales. There never seemed to be enough of either, however, and it was often the good Frédéric Bazille who bailed him out, either with money or by purchasing his pictures. It was Bazille who bought *Women in the Garden*.

Bazille, in fact, became Monet's main source of money in the early days of their friendship; Monet tended to abuse Bazille's generosity, taking his support for granted. As early as

1865, when Bazille had offered to try and place some of Monet's paintings in his home town and even promised to pay the fare to the exhibition, Monet wrote, 'I'm angry with you for not having written, you appear to have forgotten me completely. You promised to help me with my pictures, you were supposed to come and pose for some figures, and my picture depends on it. So I hope you will keep your promise, but time is passing all the same and no sign of you.'

The money was usually soon spent, however, since Monet always had a taste for good wine and always insisted on having girls in the house to help Camille. Camille's pregnancy in 1867, which resulted in the birth of their first child, Jean, added to the costs of their modest household – though Camille and Jean also provided Monet with the subjects of some of his finest paintings of this period.

Jean's birth also gave Monet an excuse for more letters to Bazille, reminding him of past promises of money. 'For the *last* time I am asking you this *favour*,' he wrote in a letter of 1867. 'I am going through the most terrible torments. I had to come back here [Sainte Adresse, his home near Le Havre] because I did not have enough money to stay in Paris while Camille was in labour . . . it pains me to think of his [the baby's] mother having nothing to eat.'

In 1868 the tide began to turn in Monet's favour again. The Salon accepted *Ships Leaving Le Havre Dock*, just one of many fine, light-filled canvases Monet was inspired to produce at this time of great artistic creativity. Although he was rejected again by the Salon in the following year, the number of art-lovers who were beginning to notice Monet and buy his work was increasing. Included among them was Louis-Joachim

Gaudibert, a business man who lived near Le Havre. He bought several of Monet's seascapes in 1868, rescuing them from creditors, and made it possible for Monet to return to Paris and set up a small studio in which he, Camille and their son Jean could live. Gaudibert also commissioned several portraits from Monet, including one of his daughter-in-law, *Portrait of Madame Gaudibert*, painted in 1868 and now in the Musée d'Orsay. Gaudibert's help did not extend to subsistence, however, and the Monet family were often short of food and other essentials.

ESCAPE TO ENGLAND

From his new base, Monet travelled back and forth to the north coast of France, near his old home, looking for subjects that might appeal to collectors of the new style of open-air (*en plein air*) painting. Among the places he painted were Honfleur and Trouville. He was in Trouville in 1870, soon after his marriage to Camille, when the Franco-Prussian War broke out. Soon, disturbing rumours were filtering through to Trouville that there was going to be a general mobilization.

On impulse, Monet boarded the first steamer for England, leaving it to the faithful Bazille to arrange for Camille and Jean to follow him. While other artists did the same as Monet, Bazille stayed in France and, like Auguste Renoir, who spent a year in the cavalry, was called up. Renoir survived, but Bazille did not, being killed in a minor skirmish in November 1870. His death deprived France of a rising talent and deeply affected Monet, whose affection for his friend went far beyond mere thankfulness for Bazille's financial help.

In England, Monet settled his family in a flat in Kensington and met up again with Camille Pissarro. Both artists were soon in contact with Paul Durand-Ruel, a picture-dealer who had become interested in Monet's work in Paris. Durand-Ruel was also a war refugee, but not a penniless one. He had a successful gallery in Paris and now set about

establishing one in London in order to introduce the new French painters to the British public, though without much success as the latter were even more conservative in their artistic tastes than the authorities of the Paris Salon.

Although Monet did not care for London as Pissaro did, he managed to make his stay in the city a productive one. The grimy city, with its mists and fogs and busy river-life, inspired him to paint in a looser style, and to plunge into daring experiments with the colours which he observed in the smoke- and fog-laden atmosphere. The clear-cut landscapes which Monet had painted at places like Sainte Adresse and Etretat in France were put aside, and a new and mysterious world began to appear in his work.

It is in his first London paintings that one can begin to discern a new direction in Monet's

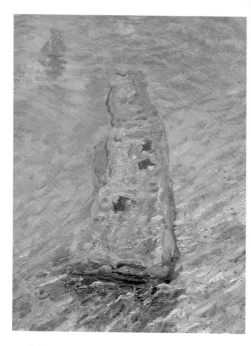

Monet's painting of the cliffs at Etretat

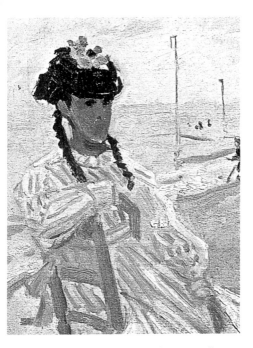

Camille Monet on the beach at Trouville

work. Years later, when he was well established in the art world and recognized as a painter of genius, he returned several times to London, which suggests that he found the same inspiration for his ideas as he did at Giverny.

RETURN TO FRANCE

Once the Franco-Prussian war was over
and the insurrection of the Communes
had been dealt with, Monet began to think
that it should be safe to take his family back
to Paris. He did not return directly to
France, however, choosing to go via Hol-
land. He stayed at a small village called
Zaandam which was located on a canal
and surrounded by flat countryside under
a vast sky. Here, Monet explored the
painting possibilities of open space in the
style of Jongkind. At the same time, he was

hankering to return to the river-side near Paris.

It was important to be near Paris, the centre of the art world, but Monet also needed to be where there were suitable subjects for open-air painting. The place he chose was Argenteuil, a small village on the Seine near Paris and a popular boating centre. Yachts and rowing-boats provided lively subjects on the river and there were cafés and other places of entertainment on its banks.

Because of Durand-Ruel's support, Monet now had a small income from his work which enabled him to live in reasonable comfort. His home with Camille now became a place where his Paris friends could visit him and discuss the ideas on art which they all shared at this time. Among Monet's more frequent visitors were Renoir, Sisley, Pissarro, Gustave Caillebotte, a talented and

wealthy young painter and collector, and Manet, with whom Monet had become a close friend.

During one arid period when he was selling few paintings, Monet wrote to Manet, 'It's getting more and more difficult. Not a penny left since the day before yesterday, and no more credit at the butcher's and baker's. Even though I believe in the future, you can see that the present is very hard indeed . . . You couldn't possibly send me a twenty franc note by return could you?'

Despite these money problems, this was a happy period for Monet and he recorded all its joys in painting after painting: Camille caught at a window behind a bank of flowers, Camille and Jean walking through fields of poppies, boats on the river, and tables set for lunch in the shade of over-hanging trees. In order to paint without the

interruption of curious passers-by, Monet built himself a floating studio, a simple flat-bottomed boat with a small superstructure and canvas awning, which he could steer to any part of the river that took his fancy. Monet was evidently well pleased with the craft, for he painted a picture of it, as did Manet, who depicted the artist at work in it.

The painters who met at Monet's house in Argenteuil had never exhibited together, though they shared many of the same ideas. It occurred to them that it would be useful to organize a show which would bring to the public's attention the new direction that art was taking.

It was not an easy matter to find a suitable gallery, for those with a reputation and good clientele tended to pander to the conservative tastes of the art-buying public, many of whom thought that paintings had to deal

with serious subjects such as mythology or portraiture, usually carried out in dark colours and with a smooth and well-varnished finish. The work of the young Impressionists, as Monet and his friends would eventually come to be called, did not meet these criteria.

Nevertheless, once the idea was put forward, a group of artists, including Monet, Degas, Berthe Morisot, Sisley and Renoir, determined to bring the exhibition about. They persuaded a photographer called Nadar to provide space in his studio in the Boulevard des Capucines for an exhibition of the new art.

The exhibition, which opened in April 1874, was not a success and was generally criticized. One critic, Louis Leroy, wrote in the magazine *Charivari*, in a piece headed 'Exhibition of the Impressionists', that Mon-

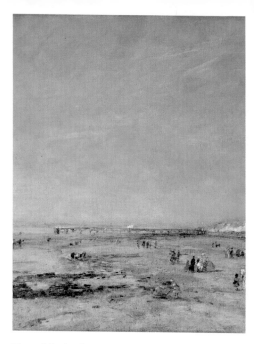

View of the beach at Trouville, by Eugène Boudin.

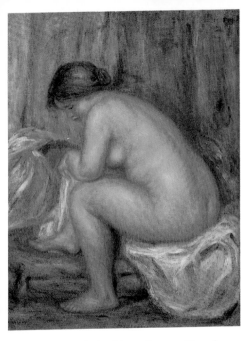

Seated nude, by Pierre Auguste Renoir

et's work was 'designs for wallpaper'. He used the title of Monet's oil sketch of the harbour at Le Havre *Impression:Sunrise*, as a weapon with which to condemn most of the exhibition.

The young artists' hopes were temporarily dashed: the public were doubtful about the work, and art-collectors thought twice before buying paintings which did not seem a good investment.

A sale of paintings by Monet, Renoir, Sisley and Morisot at the Hotel Drouot auction-rooms a year later was another disaster, with a few pictures being knocked down to derisory prices. Once more, Monet found himself in financial trouble. He was not deflected from his artistic purpose, however, which he had once summarized for an American student as being to paint, not the objects, but the colours.

He pursued his aims, despite his modest financial success, throughout the 1870s, contributing to the Impressionist exhibitions of 1876, 1877 (in which he included his superb Gare Saint-Lazare series), 1879 and 1882. The Gare Saint-Lazare group of paintings, which inspired the praise of Emile Zola, seek to capture the effects produced by smoke and sunlight at the Paris railway station.

MONET AND THE HOSCHEDÉS

One of Monet's foremost admirers and buyers at this time was an entrepreneur-business man called Ernest Hoschedé. He and his wife Alice and their two daughters lived in style in a splendid château at Montgeron, near Paris. In 1878, when Monet was in one of his troughs of despair, Hoschedé suggested that the two families, who had become good friends, should share a house at Vétheuil on the Seine. To Monet, this seemed a reasonable solution to his financial problems.

Soon after, however, Hoschedé, whose financial affairs were always a good deal more precarious than they looked, went bankrupt and spent more and more time in Paris trying to save his business. He had to auction off his collection of Impressionist paintings, which included sixteen by Monet, for very low prices.

Monet was now left as the head of both families at Vétheuil. Camille, who had borne Monet another son, Michel, never properly recovered from the birth and was not at all well. Her condition worsened during the following year, with Madame Hoschedé nursing the sick woman while Monet continued with his painting in the hope of making some money.

Camille died on 5 September 1879. Monet watched over her on her deathbed and was seized with an impulse to paint the woman

he had loved. The result was not a great work of art, but the pale creature wrapped in what seems a transparent shroud was a poignant reminder of the lovely girl who had posed for *Woman in a Green Dress*, and Monet wept as he looked at her.

Disturbed by a domestic situation which left Hoschedé's wife in his care, Monet suggested to Hoschedé that he should move out. But his friend, absorbed by his affairs in Paris, was taking little interest in his family at Vétheuil. It is difficult to establish at what point Monet and Alice became lovers, for they were both very correct and discreet, addressing each other as Monsieur and Madame and behaving in a cool and formal manner in public.

Monet could now no longer afford to keep the house at Vétheuil on his own. He moved with Alice Hoschedé and her six children

first to Poissy, nearer Paris, and then, in 1883, to a part of the country he had taken a fancy to near Giverny, much further down the Seine. At first he had a small rented house, but later he moved to another that was destined to be his home until the end of his life.

The shared home suggests that Alice and Monet now regarded themselves as the parents of a joint family, and a sentimental bond is confirmed in Monet's letters to Alice, which he wrote assiduously during his many painting-trips of the 1880s.

Although Alice kept Monet's letters to her, there is no trace of her letters to him. It is evident from Monet's letters, however, that Alice was disturbed by her precarious situation as Monet's mistress and guardian of his children – her marriage remained undissolved. Moreover, Monet's frequent ab-

sences on painting-expeditions did little to reassure her. At one point, she wrote suggesting a separation; Monet replied instantly from Etretat, where he was painting: 'You ask me to think things over and come to a decision, but I feel it impossible to think of a separation... I think of the children whom you love and who love you, but I can also see that things are coming between us.'

The main obstacle to a permanent relationship was, of course, Ernest Hoschedé. It was not until he died in 1891 that Monet and Alice Hoschedé were able to be open about their relationship, which they did by marrying in 1892.

THE ARTIST IN THE 1880s

During the 1880s Monet spent a great deal of
time travelling in search of new subjects. He
may have done so at the suggestion of his
dealer, Durand-Ruel, who was beginning to
find a regular market for the artist, or it may
have been Monet's own restless nature and
his domestic situation which impelled him to
the north coast of France, the Atlantic coast
and the South of France.

At this period the French bourgeoisie were
beginning to enjoy their leisure, spending

weekends on the river or visiting the Riviera of France and Italy, which offered pleasures hitherto reserved for the wealthy and privileged. Some would want a souvenir of their holidays and might perhaps buy Monet's views of Bordighera, Antibes, or the island of Belle Ile, off the west coast of France.

For Monet, these excursions into new territories were inspirational, especially the trips to the Mediterranean, where the brilliant sunshine and colour gave him a new range of colours to work with. As always when he was travelling, he wrote long letters to Alice, telling her about his painting problems, what he ate and how he slept, and never failing to tell her how much he missed her and the children.

In one letter from Etretat he described how he had nearly been swept out to sea by a wave. He had been painting in the lea of the

cliffs and had not noticed the tide coming in. 'A large wave threw me against the cliff. . . My first thought was that I was done for as the water dragged me down but in the end I managed to clamber out on all fours.' His easel and paintbox were washed out to sea, and Monet's main complaint was that the episode had stopped him painting until he could order some new material from Paris. 'To think,' he added in the melodramatic style he often adopted in his letters, 'I might never have seen you again.'

From Bordighera, on the Italian Riviera, he waxed lyrical about the strong light and excitedly told Alice that anyone who had not travelled in this part of the world would think he was inventing the colours he was putting down on his canvases. He painted fifty canvases during his stay at Bordighera, and Durand-Ruel had no difficulty in selling them.

A winter scene

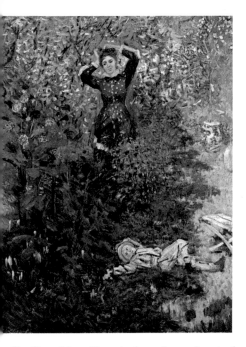

Camille and Jean Monet in the garden at Argenteuil

From Belle Ile, off the coast of Morbihan, Monet wrote to Alice telling her that the character of the coast on the island was so different from that of northern France that he was having to spend some days just getting used to it. The weather was good at first but soon worsened, inspiring Monet's usual complaints about not being able to work. Nevertheless, he managed to do more than forty canvases during a stay on Belle Ile in 1886.

He now had few doubts that his work was saleable and that Durand-Ruel would deal with it, but he was also beginning to wonder whether he would do better with other dealers or by selling directly to his public.

Monet's self-confidence and belief that the French public were now ready to accept the work of the new painters became evident when he wrote to the Minister of Public

Instruction after Manet's death in 1883. Monet offered to the nation, on behalf of a number of subscribers, Manet's *Olympia*, which had caused such a scandal when it was first shown. Manet's death, Monet pointed out, was an opportunity to recognize the 'important role in the century's history of a painter whose early death was an untimely loss to his art and country'.

No doubt Monet was also thinking of painters, including himself, who were changing the course of art, and he requested in his letter that *Olympia* should be hung in the Louvre. (It is now in the Musée d'Orsay.)

THE SERIES PAINTINGS

Monet's confidence that he had a growing reputation among art-lovers gave him the courage to take his art in a new direction. His own interest had always been in colour, and his search for subjects had been impelled by both the practical need to appeal to the public and his own need to explore the colour possibilities of different places and meteorological conditions. Now Monet decided to concentrate on one subject and to study and record the effects of light on it throughout a chosen period of time.

Monet's first group of paintings on the same subject were the ones he did of the Gare Saint-Lazare in the 1870s, though he probably did not intend these as a series. He did not set about his paintings of poplar-trees with a series in mind, though the fact that they were painted at different times of day is an indication of the direction in which his mind was going. The choice of poplars as a subject was purely fortuitous. Having heard that the line of trees was about to be cut down, Monet paid to have their destruction delayed and in the interim set about recording what must have been a familiar and well loved feature of the countryside near his home.

The first subject he chose for a series of paintings was a group of haystacks which were easily accessible from his house at Giverny. Having decided to devote himself to a study of these at every moment of the

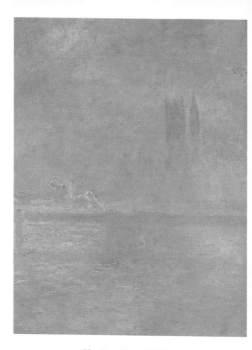

Charing Cross Bridge

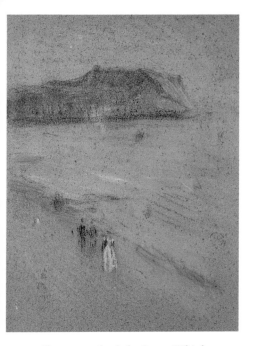

Figures on a beach, by James Whistler

day and change of weather, Monet armed himself with a number of canvases; with the help of a carrier, often Alice's daughter, Blanche Hoschede, he would set off every day to the same spot to record the changing effects of light.

Despite the comfort of working near home, Monet had his usual emotional upheavals when engaged in work. He complained to Alice every evening on his return. He wrote to his friend the critic Gustave Geffroy, saying that he was in a bad mood, was disgusted with painting and moreover was suffering from rheumatism as a result of exposure to the damp weather. Trying to explain to Geffroy what he was seeking to achieve, Monet spoke about an 'envelope' of light spreading over everything. 'I'm increasingly obsessed by the need to render what I experience', he wrote, showing that it was not merely

the outward appearance of the world that concerned him.

Though totally immersed in the pursuit of his painting ideas, Monet also had time to write to friends. One of them was James Whistler with whom Monet felt a certain affinity – he was no doubt impressed by Whistler's studies of the Thames. He also kept in touch with his old friend Boudin, and with Emile Zola and the sculptor Auguste Rodin.

Monet's first long separation from Alice after their marriage was when he decided to do a series of paintings of Rouen Cathedral. Monet had decided to paint the front of the cathedral at various times of the day and he installed himself in rooms with a good view of the cathedral's façade in the spring of 1892. He finished the series, which included some 200 sketches, drawings and completed oil-paintings, in 1894.

In his first letter from Rouen Monet was full of optimism, telling Alice he had a clear view of his aims, but adding with his habitual pessimism that he did not think the weather would remain fine. Within two days he was complaining about the unsettled weather and telling Alice that 'this cursed cathedral is hard to do'. Nevertheless, by the end of March, three weeks after his arrival, he was writing to say, 'Fourteen paintings today, it's unprecedented'.

While away, Monet's mind turned more and more to his new home at Giverny. He missed Alice and he missed the garden that he was creating. He found time at Rouen to visit the Botanical gardens and accepted the gift of a climbing begonia. Back home, almost before he had unpacked, he was writing to the Prefect of the Eure to protest against official objections to the idea of creating a lily-pond.

Monet's new home at Giverny was on the river Epte, a tributary of the Seine and he had conceived the idea of drawing some of the water from the Epte to create a pond in a swampy part of his grounds. The creation of the water-garden, begun in 1893, was to become an obsession. In time, he even began to look upon it as his greatest creation.

Early in the 1895 Monet visited Norway, where Alice's brother Jacques lived. His journey was partly for painting purposes, but also to present himself to a new public who had become aware of his growing fame. He was written about in the local newspapers – too much so, he thought – and a banquet was arranged to honour him. The weather was cold however, it was February and Monet longed to return to Giverny, where spring would soon be arriving.

After this trip to Norway, Monet remained at Giverny. He had built a studio where he could finish the paintings that he had started abroad. While at Giverny, he could also give more time to his garden, pressing his family to help him dig up beds and plant new arrangements. He employed a gardener, to whom he would give exact instructions about the planting of such items as 300 poppies, sixty sweet peas, pots of agrimony, sage and water-lilies.

SUCCESS

By the end of the century the ideas launched on the world by the Impressionists had taken root, though most of the original members of the group had since followed their own paths: Degas, never very interested in colour theories, had become the master of ballet scenes and intimate glimpses of the female *toilette*; Cezanne, disappointed that his structural aims were not understood, had retired to his family home at Aix-en-Provence; and Renoir, beset with arthritis, had also moved to the warm south. Many of them had died:

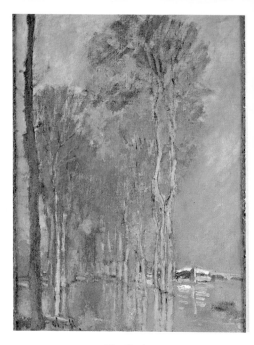

The flood

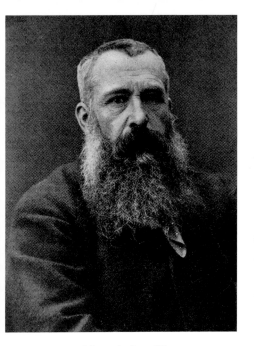

Monet in later life

Manet, the oldest, in 1883; Berthe Morisot, founder-member of the Impressionist Exhibitions, in 1895; and Sisley, who, like Pissarro and Monet had remained faithful to Impressionist ideas, in 1899.

The disappearance of his old friends made Monet himself aware of the passage of time and of his failure, as he saw it, to achieve what he had set out to do. Worldly success meant nothing to him, though he enjoyed his new affluence and the absence of financial pressure. What really concerned him was to find a successful way of depicting his feelings about the world in paint. In 1870, when he had found himself in London, he had produced some paintings that were different: a new vision of colour diffused over the entire canvas. He decided to visit London again in 1899, but this time he would go as a successful painter whose work now fetched 6,000 francs and more. He took a room at the

Savoy hotel, overlooking the same part of the river that he had painted forty years earlier.

As was his habit, Monet wrote to Alice as soon as he arrived, telling her about his arrangements. He complained that he did not think the weather would last, but he was intending to start nevertheless. He got to work at his usual impatient speed, filling canvas after canvas which he would finish off later in his studio. He also made arrangements to work on the terrace of St. Thomas' hospital from which there was a good view of the Houses of Parliament; while there, he was offered tea, sandwiches and cakes every afternoon.

It did not take long for Monet's good spirits to disappear, however; the weather became cooler and then it began to snow. 'Darling,' he wrote to Alice,'I am in a state of despair.' Despite his despair, Monet managed to have

a busy social life. Through his friend, the statesman Georges Clemenceau, he was introduced to London society; and through John Singer Sargent, to the artistic circles. Alice apparently became jealous, for Monet had to write to her to say that she had no reason to be so, and that he could not understand where she had got the idea that Clemenceau could lead him into bad company.

Clemenceau, who was Prime Minister of France from 1900-01 and again during World War I, was a great admirer of Monet's work. He was a patriot who was proud that Monet was a Frenchman, a factor that no doubt helped to establish the painter as a national figure.

Monet was to visit London again in 1900 and 1901, choosing to go in winter when the fogs and mists were at their thickest. He

produced some one hundred paintings, none of which satisfied him; but they have delighted many since. Their first public exhibition in 1904 was an important artistic event.

FADING SIGHT

After his expeditions to London, Monet concentrated on his garden at Giverny. By now, he had completed his pond, which was surrounded by trees and was crossed by a charming Japanese foot-bridge covered in creepers. He had filled his garden with unruly beds of irises, begonias, lilacs and other flowers, which he painted incessantly, making his garden as much an inspiration for his work as Mont Sainte-Victoire was for Cézanne's.

In 1900 Monet had received the first intima-
tion of a problem that was to dog him for the
rest of his life. As a result of an accident he
lost the sight of one eye. The blindness was
only temporary but it slowed his work rate,
which was one reason why his London
pictures were not exhibited until 1904.

He had planned to exhibit the paintings in
London but when the time came he lost
confidence in them, writing to Geoffroy that
he had worked too much on them and they
had lost their spontaneity. Whatever he
thought of his work, the public's apprecia-
tion was growing ever greater :Monet told
Geoffroy that he had a cheque from Durand-
Ruel for 10,000 francs.

Perhaps it was the comfort of his financial
security that made Monet buy a car. He had
always wanted to go to the Prado in Madrid
to look at the Velázquez paintings, and on

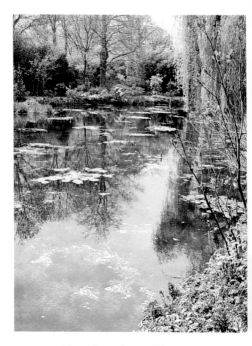

Monet's garden at Giverny

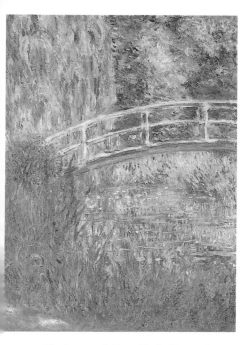

The Japanese bridge with the lily-pond

the spur of the moment he drove to Spain. He was away for three weeks.

Despite the problems with his eyes, which had developed cataracts, Monet continued to paint, mostly in his garden at Giverny. In 1908 he received an invitation to move out of Giverny which he could not resist.

A friend of John Singer Sargent, Mr Curtis, invited Monet and Alice to stay at the Palazzo Barbaro, Venice. The memories of previous visits to the south with its brilliant light and colour fired Monet's imagination and he set off for the Serenissima. The light shimmering on the water and buildings fulfilled all his expectations and he was immediately inspired to paint. In order to do so with freedom and with views that he liked, he moved to the Hotel Britannia at the junction of the Grand Canal and the lagoon, and set up a room as a studio.

The uncertain, diffuse light of the water-filled city provided Monet with the kind of atmosphere which inspired his vision of light and colour, and he set to work putting on canvas his views of the lagoon, Santa Maria della Salute, the Doges' palace and other buildings. It was October and the weather was about to break. He wrote to Durand-Ruel ,'What a shame I did not come here when I was a younger man, when I was full of daring.' No one looking at the superb paintings today would accuse them of a lack of daring; but Monet always felt that he had not achieved his aims.

MONET ALONE

Monet's hopes of spending several months in Venice were doomed to disappointment, for both he and Alice fell ill and they had to return to Giverny. Monet fell into one of those pits of despondency which prevented him from working. He wrote to Geoffroy at the end of 1908 to tell him that since his return from Venice he had done no painting at all. Fortunately, Durand Ruel's great interest in the water-lily paintings that Monet had been doing for some time (he had had a series of lily-pond paintings exhibited in

1900) roused the artist to action. Monet and Durand-Ruel selected forty-nine paintings for an exhibition at Durand-Ruel's Paris gallery in May 1909, which was enormously successful.

Then came Alice's death in May 1911, plunging Monet into further depression. With Alice's death, he lost not only the faithful woman who had looked after his children as well as her own, and who had patiently encouraged him at moments when his confidence had weakened; he lost the confidante to whom he could write about all his troubles and problems when he was away from home.

Of course, Monet's family and friends visited him, but he found it difficult to raise his spirits and spent hours thinking of Alice and rereading her letters. Life had lost its savour and he wrote to Durand-Ruel, 'I realise how illusory

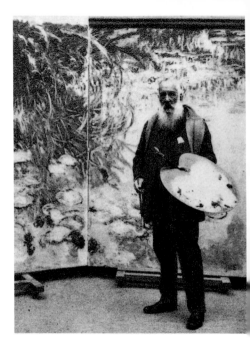

Monet with his lily-pond frieze

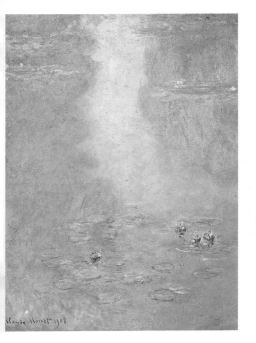

The lilies

my undeserved success has been. I still hold out hopes of doing better but age and unhappiness have sapped my strength.'

An exhibition of twenty-nine canvases at the Galerie Bernheim in Venice brought Monet considerable attention in 1912, but the artist himself remained very much in lonely isolation at Giverny. Even the outbreak of war in 1914 seemed of little concern to him. Only Blanche Hoschedé was with him, as she would remain permanently after her husband died. Blanche tried to encourage him, reminding him of all he had achieved, but Monet seemed inconsolable.

Eventually, Monet was roused from his depression by his old friend Georges Clemenceau, who, despite his preoccupations as Prime Minister of France in wartime, reminded him of his unfulfilled ambition to fill a room with his lily-pond pictures using a

circular frieze. Monet demurred at first, thinking it impossible to complete so ambitious a project. Clemenceau insisted that Monet could do it. Giving more practical help, he introduced Monet to his friend Dr Charles Coutela, who began to treat the painter's eyes.

With his spirits raised at the prospect of achieving the ambition he had had for so long, Monet built a new studio in the garden at Giverny. It was capable of holding canvases 200 cm. in height and 426 cm. in width, which would be carried by easels on wheels so that they could be moved easily. He began to work on this, the greatest of his water-lily series, in 1916. It was a formidable project for a man of seventy-six suffering from eye trouble and it greatly impressed the art-dealers René Gimpel and Georges Bernheim, when they visited Monet once the work was begun.

'We seem to be present at one of the first hours in the birth of the world,' Gimpel wrote later. 'It is mysterious, poetic and unusual; it is a strange and pleasant sensation to be surrounded with water on all sides.' This was one of the first comments that seemed to have some understanding of what Monet was striving for – not paintings of a pretty lily-pond, but a vision of a constantly evolving world of creation.

Monet had been eliminating horizons and perspective from his work, devices which give most paintings the look of a theatre set, and was making his canvases limitless spaces in which colours and shapes floated like spiral nebulae. He was striving for the impossible, he was constantly aware of his failure.

At the end of the war, Monet asked Clemenceau to offer two paintings on his behalf to

the French Government in celebration of the
armistice. His friend accepted with alacrity,
though he had a greater ambition for Monet
than this: he wanted to establish him as one
of France's leading painters. In pursuance of
this, he arranged that twelve of Monet's
paintings should be hung in the Hotel Biron
(the Rodin Museum). The great plan for a
room of lily-pond paintings joined in a great
circle was gradually becoming a real possi-
bility. There was still much to be done,
however, and Monet was aware that time
was running out. His eyes were troubling
him again, though he was reluctant to have
an operation in case it was a failure and he
was left totally blind. In the end, he had no
choice. In 1923 Dr Coutela arranged the
operation, which restored the sight of one
eye.

Writing to the doctor soon afterwards,
Monet said that he had miraculously recov-

ered his sight 'at a stroke'; he could see
everything once more and was working
passionately. Was this bravado or had a
miracle occurred? Monet's last paintings
suggest that he was unable to see shapes
clearly but his sense of colour is stilll there.
His canvases are a whirl of brilliant colour,
giving a sense of what Gimpel called 'the
birth of the world'.

Monet worked assiduously until the end of
his life. He died quietly at his beloved
Giverny on 5 December 1926. During his
last years he rarely moved out of his garden
and the studios there; he was happy in the
company of all those who had helped to
create his little Eden, including Blanche
Hoschedé and his servants and gardeners.
He was seldom alone, as he was constantly
visited by his friends and by thousands of art-
lovers from all over the world who wanted a
glimpse of the grand old man of Impression-

ism. Many artists went to the countryside round Giverny to set up their own studios, and eventually a museum was opened by American painters to show their own Impressionist work. Giverny became the centre of a Monet industry, though its inspiration was not there to see it.

In May 1927, Monet's great lily-pond pictures were exhibited at the Orangerie in the Tuileries. They were a fitting memorial to a painter who, with his artist-friends, had opened new avenues in the exploration of artistic expression; and to a man who often despaired of achieving his aims, but never gave up.

CHRONOLOGY

1840
Claude Monet is born in Paris on 14 November.
The family later moves to Le Havre.

1859
Monet moves to Paris to paint. He meets Camille
Pissarro, the originator of the Impressionist style.

1861
Monet is sent to Algeria for seven years' military
service. He returns to France after an illness and
stays in Paris after managing to find a substitute.

1862
Monet meets Sisley, Renoir and other painters at
the Paris studio of Charles Gleyre.

1863
Monet breaks away from the studio and paints
independently with his friend Bazille.

1864

Monet and Bazille set up house at Honfleur, near Le Havre.

1865

Bazille and Monet return to Paris. Monet has two paintings accepted for that year's Salon.

1866

Monet receives a prize at the Salon for his painting of Camille Doncieux. Camille becomes his lover.

1867

Camille gives birth to their son Jean.

1870

Monet marries Camille. When the Franco-Prussian war breaks out, Monet leaves for England to avoid being called up. Bazille is killed in action in November.

Camille joins Monet and they set up house in Kensington.

After the war, the family moves to Argenteuil.

1874

The Impressionists' first exhibition meets with public scepticism.

1878

Monet and family move to a house in Vétheuil with business man Ernest Hoschedé and his wife Alice.

1879

Camille dies on 5 September.

1883

With Ernest absent in Paris, Monet and Alice move to Giverny.

1892

Monet marries Alice after Ernest's death the previous year.

1894

Monet finishes the Rouen Cathedral series. Back in Giverny, he dedicates himself to the creation of a lily pond in the garden.

1899–1901

Monet visits London and paints many views of the Thames. He is troubled by a growing blindness.

1904

The exhibition of Monet's London pictures is a great success.

1908

Monet and Alice visit Venice.

1911

Alice's death plunges Monet into depression.

1916

Monet begins work on the water-lily series, struggling with worsening cataracts.

1923

An operation to remove Monet's cataracts restores the sight in one of his eyes.

1926

Monet dies at Giverny on 5 December.

LIFE AND TIMES

Julius Caesar
Hitler
Monet
Van Gogh
Beethoven
Mozart
Mother Teresa
Florence Nightingale
Anne Frank
Napoleon

LIFE AND TIMES

JFK
Martin Luther King
Marco Polo
Christopher Columbus
Stalin
William Shakespeare
Oscar Wilde
Castro
Gandhi
Einstein

FURTHER MINI SERIES INCLUDE

ILLUSTRATED POETS

Robert Burns
Shakespeare
Oscar Wilde
Emily Dickinson
Christina Rossetti
Shakespeare's Love Sonnets

FURTHER MINI SERIES INCLUDE

HEROES OF THE WILD WEST

General Custer
Butch Cassidy and the Sundance Kid
Billy the Kid
Annie Oakley
Buffalo Bill
Geronimo
Wyatt Earp
Doc Holliday
Sitting Bull
Jesse James

FURTHER MINI SERIES
INCLUDE

THEY DIED TOO YOUNG

Elvis
James Dean
Buddy Holly
Jimi Hendrix
Sid Vicious
Marc Bolan
Ayrton Senna
Marilyn Monroe
Jim Morrison

THEY DIED TOO YOUNG

Malcolm X
Kurt Cobain
River Phoenix
John Lennon
Glenn Miller
Isadora Duncan
Rudolph Valentino
Freddie Mercury
Bob Marley